ANGELS AND CUPIDS

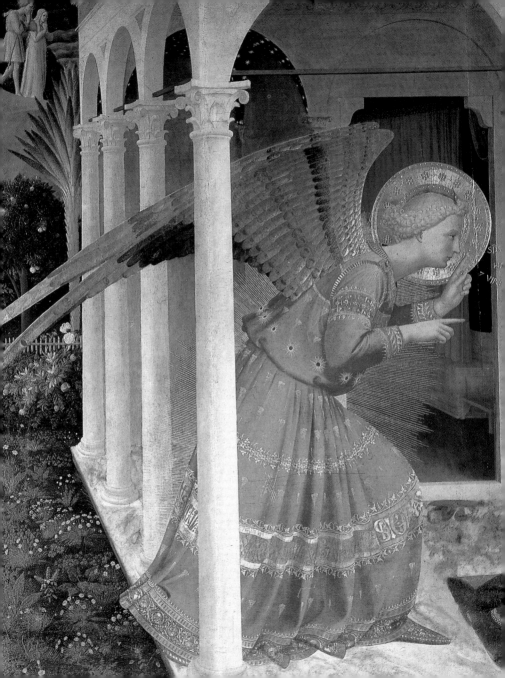

ANGELS

—AND—

CUPIDS

EDITED BY
SYLVIA LAWRENCE

RIZZOLI
NEW YORK

First published in the United States of America in 1993 by
RIZZOLI INTERNATIONAL PUBLICATIONS, INC.
300 Park Avenue South, New York, NY 10010

First published in the United Kingdom in 1993 by
Charles Letts & Co Ltd
Letts of London House
Parkgate Road
London SW11 4NQ

Designed and edited by
Anness Publishing Limited
Boundary Row Studios
1 Boundary Row
London SE1 8HP

ISBN 0-8478-1774-1

LC 93-85149

'Letts' is a registered trademark of Charles Letts & Co Ltd

Editorial Director: JOANNA LORENZ
Project Editor: CORTINA BUTLER
Designer: LISA TAI
Text Research: DAVID SCOTT-MACNAB
Photographer: JOHN FREEMAN

Printed and bound in Italy

Contents

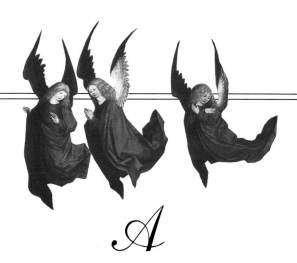

A
Glittering
Host

*T*he helmed Cherubim
And sworded Seraphim,
Are seen in glittering ranks with wings displayed.

John Milton, *On the Morning of Christ's Nativity* (1629)

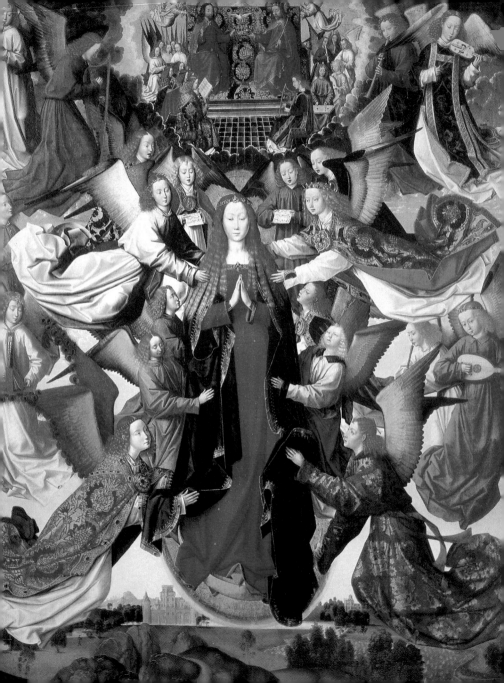

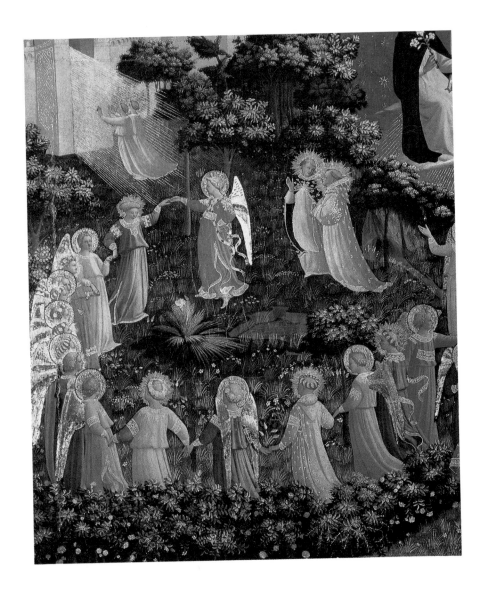

\mathcal{A}ngels are everywhere distributed about,
as officers of the world, with equal
power, zeal and kindness.

John Colet (1467–1519), *Dionysius on the Celestial Hierarchy*, IX
trans. J.H. Lupton, 1869

\mathcal{M}illions of spiritual creatures walk the Earth
Unseen, both when we wake, and when we sleep.

John Milton, *Paradise Lost* (1667), IV, 677–8

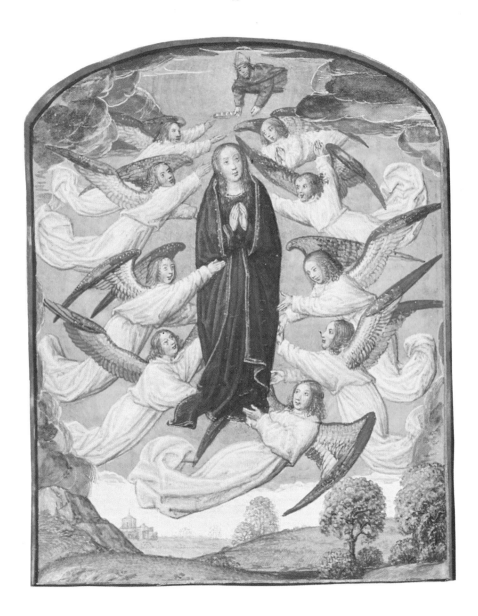

*T*here appeared to me very beautiful rainbows,
as on former occasions, but still more beautiful,
with a light of the purest white, in the centre of
which was an obscure earthly something; but
that most lucid snow-white appearance was
beautifully varied by another lucidity . . . and, if I
rightly recollect, with flowers of different colors
round about.

Emanuel Swedenborg, *Larger Diary*, 21 October, 1748

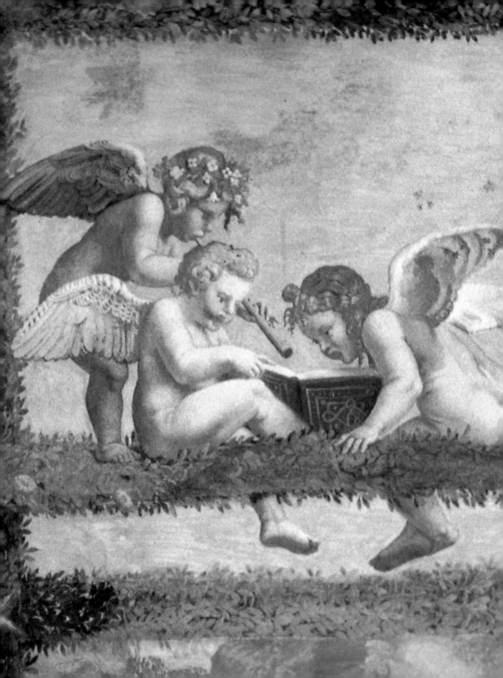

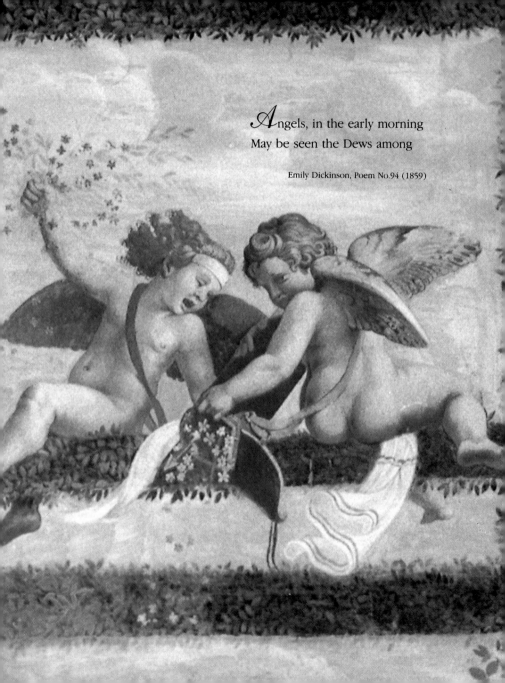

*A*ngels, in the early morning
May be seen the Dews among

Emily Dickinson, Poem No.94 (1859)

\mathcal{T}heir garments are white, but with an unearthly whiteness. I cannot describe it, because it cannot be compared to earthly whiteness; it is much softer to the eye. These bright Angels are enveloped in a light so different from ours that by comparison everything else seems dark. When you see a band of fifty, you are lost in amazement. They seem clothed with golden plates, constantly moving, like so many suns.

Père Lamy

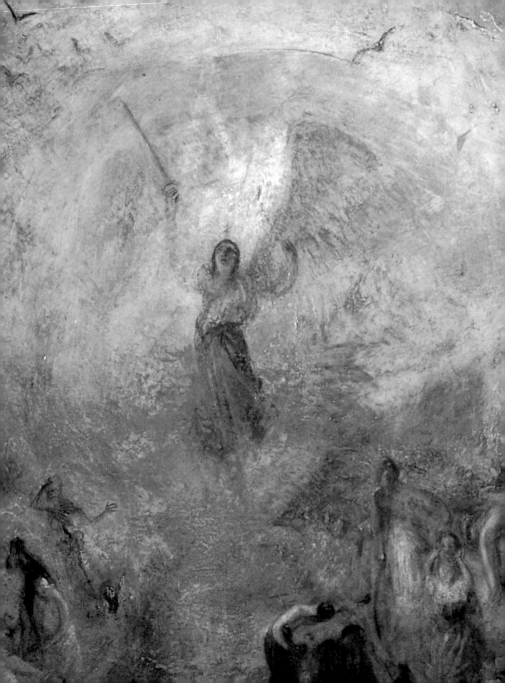

ℳngel Garland

ℳ simple method used by children to make paper chains can be adapted to make festive decorations. Choose an image of a woman and photocopy it several times – how many times depends on how many garlands you plan to make. Take a piece of textured or plain gold wrapping paper and cut it

into long strips about ½ in (1.5 cm) wider than the height of your image – the one used here is approximately 6 in tall (15 cm). Starting at one short end, fold the paper into equal-width concertina pleats. For this garland each pleat is about 4 in (10 cm) wide. Cut out the photocopied image and place it

onto the top pleat. Draw round it with a pencil adding wings and a halo round the head. Make sure that both wings are drawn right to the edge of the folds so that when you cut round the outline about 2 in (5 cm) of the fold is left uncut on either side of the pleat. When the pleat is then opened out it forms a chain of angels. Stick cut-out images onto the chain at intervals along the line to add detail. Join together several chains for longer garlands which can be suspended from the branches of a Christmas tree by thin gold threads or attached at intervals around the room or up the stairs.

Guardian Angels

*E*very man hath a good and a bad angel attending on
him in particular, all his life long.

Robert Burton, *Anatomy of Melancholy* (1621), I.ii.1.2

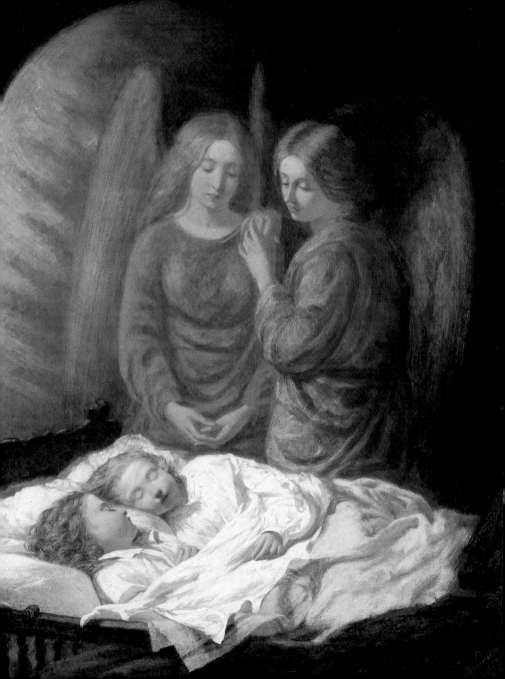

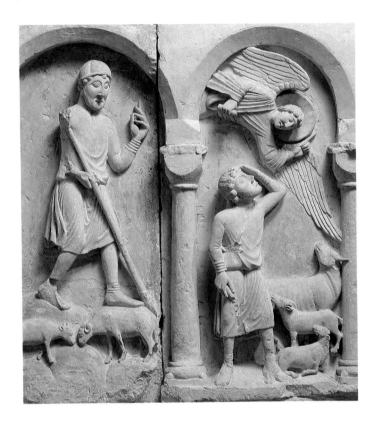

\mathcal{A}pparently, Russian divisions had surrounded a Finnish army unit. The Finns had prayed for help and in the middle of the night had seen a gigantic angel, hanging with outstretched wings above the Finnish camp. The Russians had not been able to find the surrounded Finns.

H.C. Moolenburgh, *A Handbook of Angels*
trans. Amina Marix-Evans, 1984

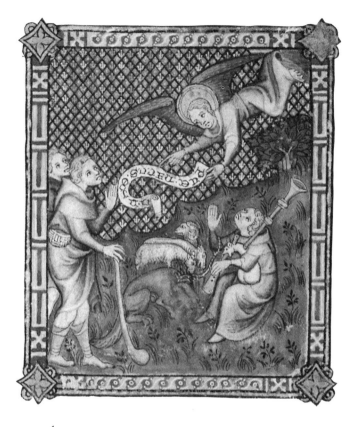

\mathcal{A}nd, lo, the angel of the Lord came upon them, and the glory of the Lord shone round about them: and they were sore afraid.

Gospel of St. Luke, 2:9

\mathcal{T}here are two angels, that attend unseen
Each one of us, and in great books record
Our good and evil deeds. He who writes down
The good ones, after each action closes
His volume, and ascends with it to God.
The other keeps his dreadful daybook open
Till sunset, that we may repent; which doing,
The record of the action fades away,
And leaves a line of white across the page.

Henry Wadsworth Longfellow, *The Golden Legend* (1851), VI

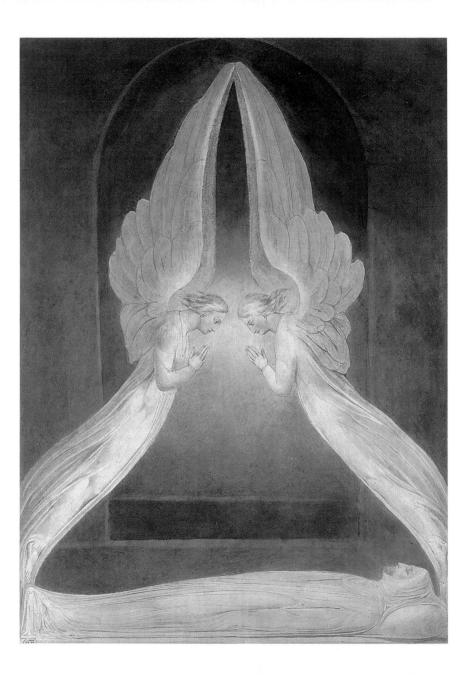

\mathcal{I}'ve heard that little infants converse by smiles and signs
With the guardian band of angels that round about them shines,
Unseen by grosser senses; beloved one! doest thou
Smile so upon thy heavenly friends, and commune with them now?

Caroline Anne Southey, *The Dying Mother to her Infant* (1844), st. 14

*M*atthew, Mark, Luke, and John,
The bed be blest that I lie on.
Four angels to my bed,
Four angels round my head,
One to watch, and one to pray,
And two to bear my soul away.

Thomas Ady, *A Candle in the Dark* (1655)

*A*round our pillows golden ladders rise,
And up and down the skies,
With winged sandals shod,
The angels come, and go, the Messengers of God!

Richard Henry Stoddard (1825–1903), *Hymn to the Beautiful*

*A*nd Jacob went out from Beersheba, and went
towards Haran. And he lighted upon a certain place,
and tarried there all night, because the sun was set; and
he took of the stones of that place, and put them for his
pillows, and lay down in that place to sleep. And he
dreamed, and behold a ladder set up on the earth, and
the top of it reached to heaven: and behold the angels
of God ascending and descending on it.

Genesis, 28:10–12

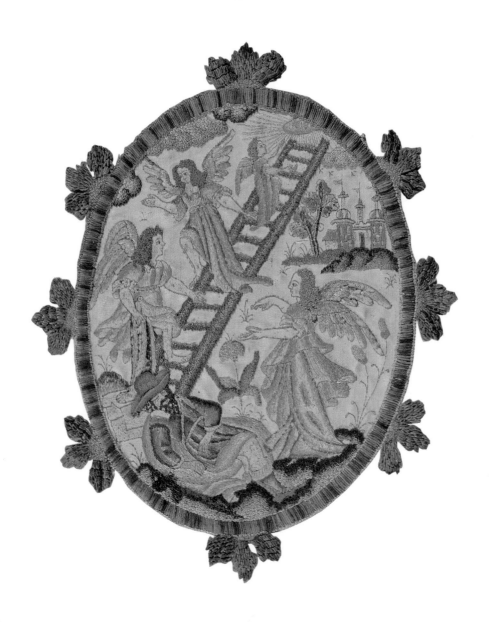

*A*ngel Box

*D*ecorating surfaces with cut-out scraps of paper – decoupage – had its heyday in Victorian times but images from any period can be used; these angels are from a Renaissance painting. Make sure that the shape of the angels you choose is quite bold so that they stand out.

*C*hoose a plain box and paint it all over with acrylic paint in a colour to harmonise with the images you have chosen. Cut out the images carefully with small, sharp scissors. Position them on the box, experimenting with different arrangements before sticking them down. Paint on any extra decoration such as the ribbons on the top of this box with a small brush.

*W*hen everything is quite dry, give the box a couple of coats of varnish. Use a coloured varnish if you want a mellow antique effect. For extra depth of colour apply a layer of coloured wax when the varnish is dry.

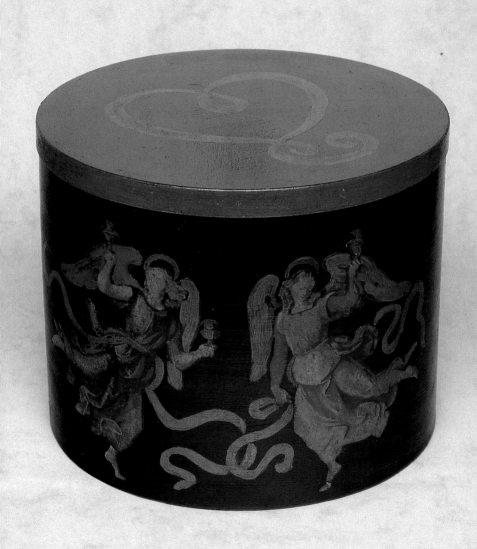

First
Among
Angels

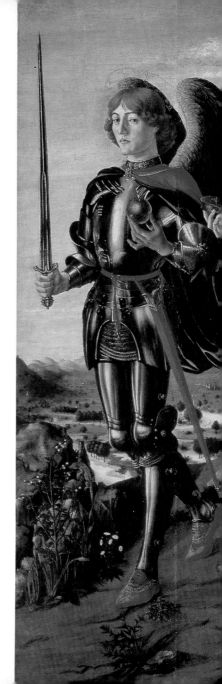

We therefore hold
that those two societies
of angels . . . the one
good in nature and
upright in will, the other
upright in nature and
perverse in will,
. . . are symbolized by
the names light and
darkness.

St. Augustine, *The City of God*
(AD 426), XI, 3²
trans. J.W.C. Waugh, 1963

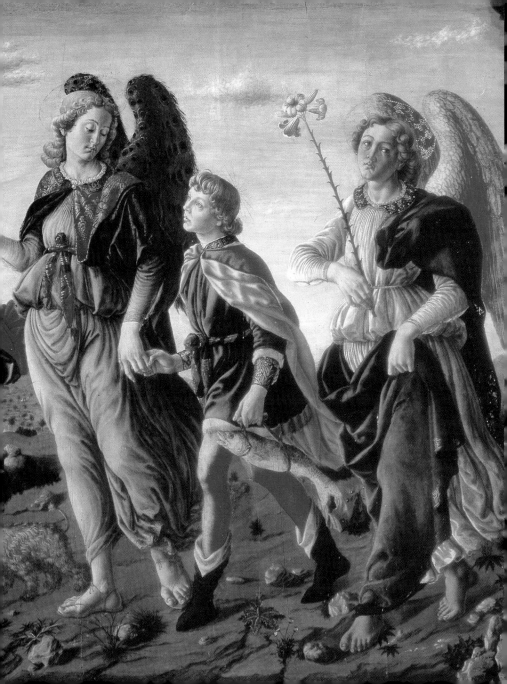

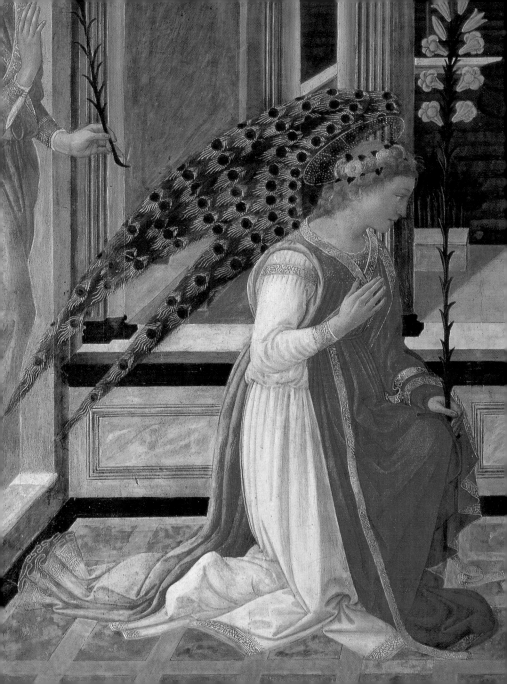

GABRIEL

\mathscr{A}nd in the sixth month the angel Gabriel was sent from God unto a city of Galilee, named Nazareth, To a virgin espoused to a man whose name was Joseph, of the house of David; and the virgin's name *was* Mary. And the angel came in unto her, and said, *Hail, thou that art* highly favoured, the Lord is with thee: blessed *art* thou among women.

Gospel of St. Luke, 1: 26–27

OF RAPHAEL DESCENDING TO PARADISE

At once on the eastern cliff of Paradise
He lights, and to his proper shape returns,
A Seraph winged: six wings he wore, to shade
His lineaments divine; the pair that clad
Each shoulder broad, came mantling o'er his breast
With regal ornament; the middle pair
Girt like a starry zone his waist, and round
Skirted his loins and thighs with downy gold
And colours dipped in Heaven; the third his feet
Shadowed from either heel with feathered mail,
Sky-tinctured grain. Like Maia's son he stood,
And shook his plumes, that heavenly fragrance filled
The circuit wide.

John Milton, *Paradise Lost* (1667), V, 275–87

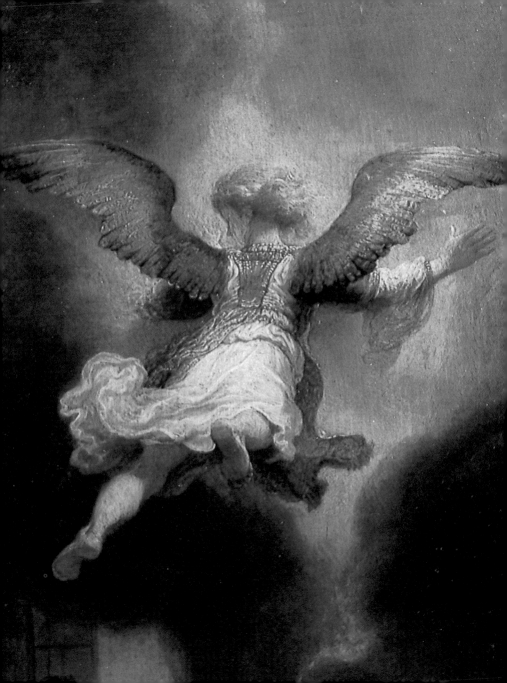

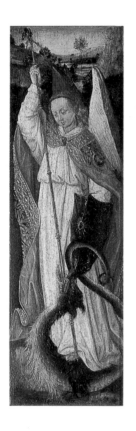

MICHAEL

*A*nd there was war in heaven: Michael and his angels fought against the dragon; and the dragon fought and his angels, And prevailed not; neither was their place found any more in heaven.

Revelations, 12:7–8

*O*n a starred night Prince Lucifer uprose.
Tired of his dark dominion swung the fiend . . .
He reached a middle height, and at the stars,
Which are the brain of heaven, he looked, and sank.
Around the ancient track marched, rank on rank,
The army of unalterable law.

George Meredith, *Lucifer in Starlight* (1883)

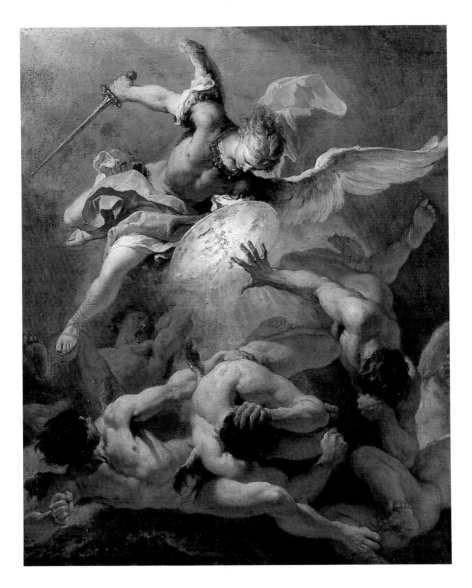

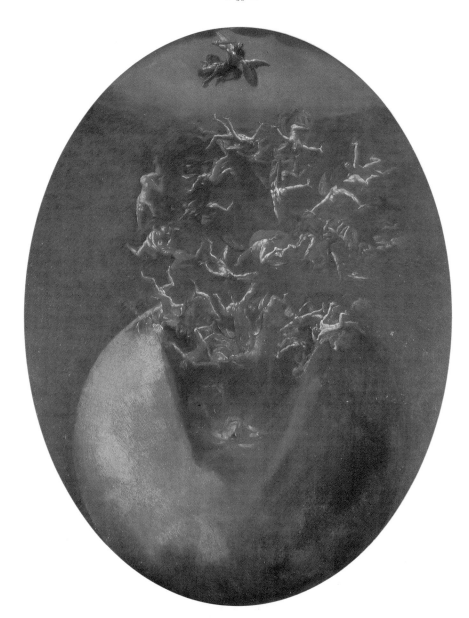

LUCIFER FROM HEAVEN

*S*o call him, brighter once amidst the host
Of angels than that star the stars among
Fell with his flaming legions through the deep
Into his place.

John Milton, *Paradise Lost* (1667), VII, 131–5

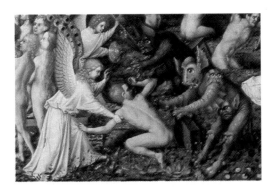

*S*ometimes Satan, we read, transforms himself into an angel of
light in order to test those who need to be instructed or deserve to
be deceived (2 Cor. 11:14). There is need of God's great mercy to
ensure that no one who thinks he has angels for friends shall find
he has evil demons for his deceivers.

St. Augustine, *The City of God* (AD 426), XIX, 9
trans. J.W.C. Waugh, 1963

Christmas Tree Angel

Draw two angel shapes about 4½ in (11 cm) tall on cream satin. With gold embroidery thread, embroider the eyes and mouth on one angel. Cut two 6 in (15 cm) squares of cream organza. Fuse the squares together with double-sided fusible interfacing then draw the wings on the square. Draw a strip for the ruff 6½ × 1 in (16 × 3 cm) on another piece of organza with a scalloped edge along one long side.

Run a line of gold glitter paint along the outline of the wings and along the edges of the ruff. Decorate the wings and ruff with dots of glitter paint. With tweezers, stick tiny gold sequins on the wet paint. Decorate the hem of the angel pieces in the same way leaving a ¼ in (6 mm) plain seam allowance. Decorate the back of the wings.

Cut out all the pieces then stitch the angels together with right sides facing, taking a ¼ in (6 mm) seam allowance and leaving a gap in the seam for turning. Snip the curves, turn to the right side and stuff with toy filling. Slip stitch the opening.

Gather the straight edge of the ruff and sew around the angel's neck. Sew 5 in (13 cm) lengths of gold lurex yarn to the top of the head and glue sequins to the hair. Bend fringed gold wool into a ring and sew it to the back of the head as a halo. Sew the wings to the back of the angel and then hang the angel on a loop of gold thread.

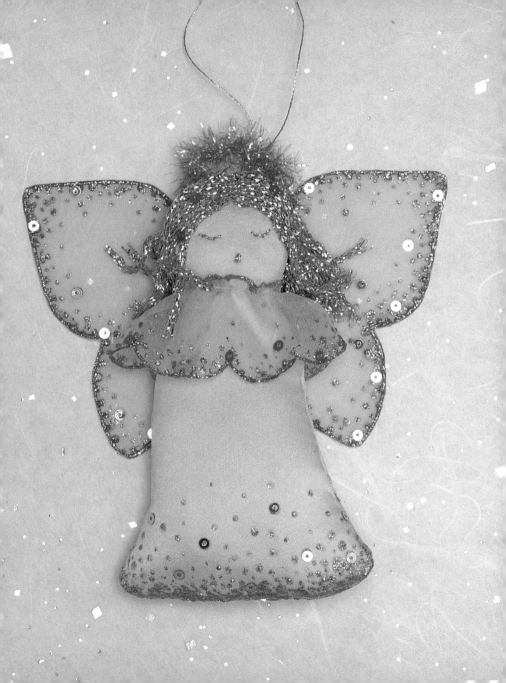

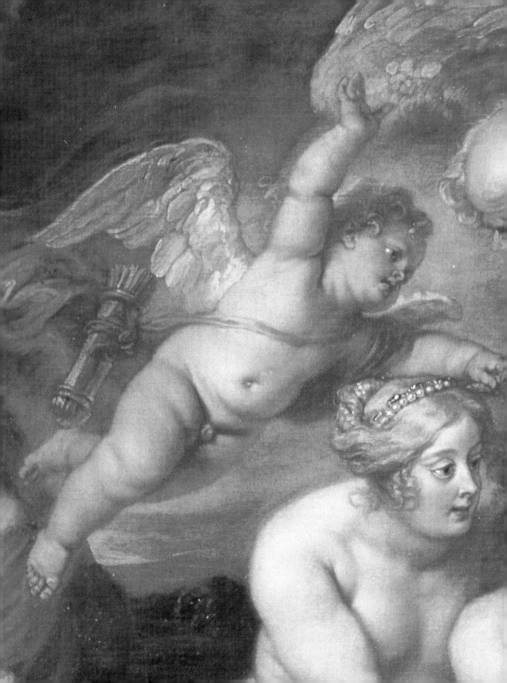

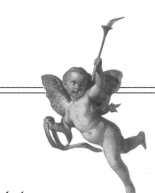

*M*essengers of Love

*C*upid, where is thy golden quiver now?
Where is thy sturdy Bow? and where the fire,
Which made ere this the Gods themselves
to bow?

Thomas Watson, *Hekatompathia or Passionate Centurie
of Love* (1582), no. 70

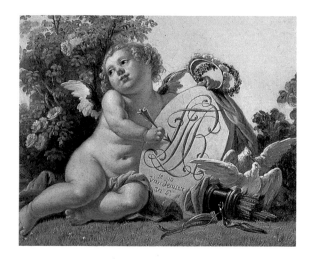

*L*ove's heralds should be thoughts . . .
Therefore do nimble-pinioned doves draw love,
And therefore hath the wind-swift Cupid wings.

William Shakespeare (1564–1616), *Romeo and Juliet*, II.v.4–8

*H*ere Love his golden shafts employs, here lights
His constant lamp, and waves his purple wings,
Reigns here and revels.

John Milton, *Paradise Lost* (1667), IV, 763–5

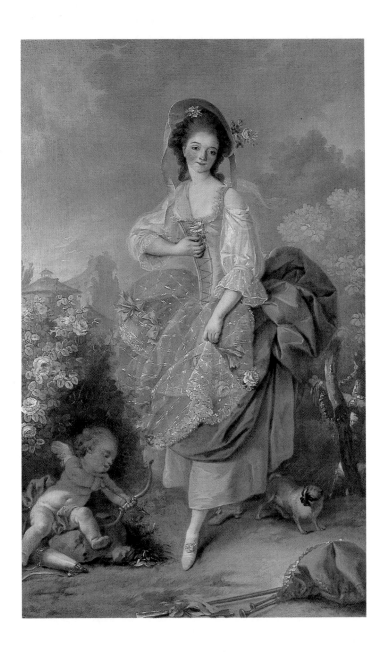

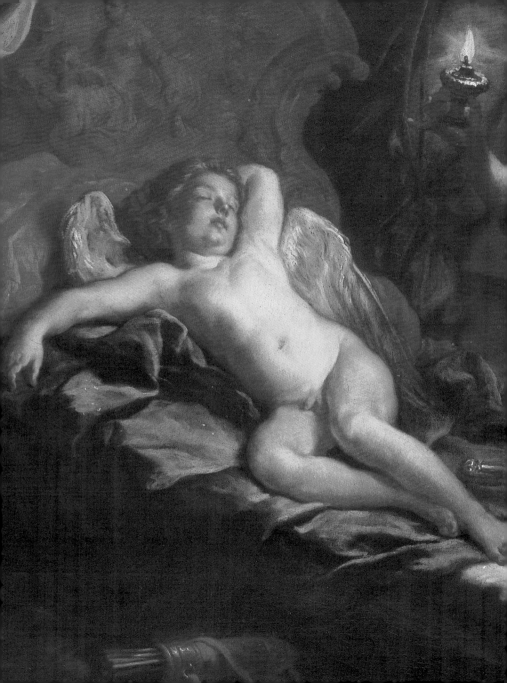

\mathcal{T}hen Psyche . . . brought out the lamp. . . . But as soon as the light was presented and the secret of their bed became plain, what she saw was . . . none other than Cupid, the fair god fairly lying fast asleep. At the sight the flame of the lamp was itself gladdened and flared up. She [Psyche] saw a rich head of golden hair dripping with ambrosia, a milk-white neck, and rosy cheeks over which there strayed coils of hair becomingly arranged, some hanging in front, some behind, shining with such extreme brilliance that the lamplight itself flickered uncertainly. On the shoulders of the flying god wings sparkled dewy-white with glistening sheen, and though they were at rest the soft delicate down at their edges quivered and rippled in incessant play.

Lucius Apuleius (2nd Century AD), *The Golden Ass (Metamorphoses)*, V.22.1–6
trans. E.J. Kenney, 1990

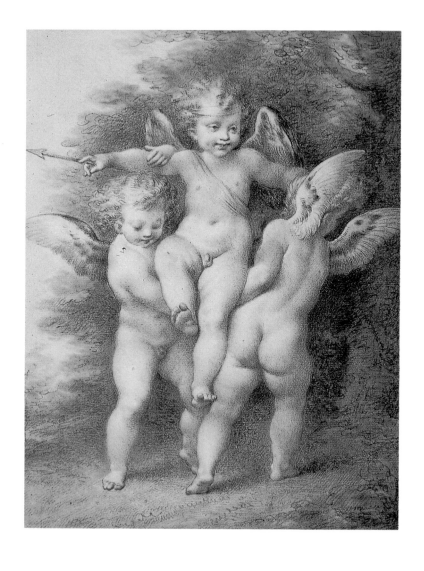

*B*ut let still Silence true night watches keep,
That sacred peace may in assurance reign,
And timely sleep, when it is time to sleep,
May pour his limbs forth on your pleasant plain,
The whiles an hundred little winged loves,
Like diverse feathered doves,
Shall fly and flutter round about your bed,
And in the secret dark, that none reproves,
Their pretty stealths shall work, and snares shall spread
To filch away sweet snatches of delight,
Concealed through covert night.

Edmund Spenser, *Epithalamion* (1591), 353–63

Cupid Stencil

Stencils can be used to decorate almost any flat surface – walls, floors, furniture, boxes, even fabric. Find an image of cupids that you like or copy this image. Scale it up to an appropriate size using a grid or a photocopier. Make the image fairly large otherwise cutting the stencil is difficult. Spend some time planning the design to make it as simple as possible. Include plenty of bridges between different parts of the design or the stencil will be very fragile.

Tape a piece of acetate over your design and trace the design onto the acetate using a waterproof pen and

marking the area to be cut away. This is what the finished picture will be. Create a separate stencil for each colour. Two stencils have been used here for the cupids and a third for the ribbons and bows. Cut carefully round the outline with a craft knife, taking care not to rip the acetate.

*T*ape the stencil with masking tape onto the surface to be decorated. Use acrylic paint mixed to a creamy consistency and apply it through the stencil with a dry sponge. Vary the thickness of paint to give subtlety of tone. Let the first colour dry before taping over the second stencil and applying the second colour. Add details of eyes and mouth with a small brush. When the paint is quite dry, you can, if you wish, apply a coloured varnish to give a glowing antique effect.

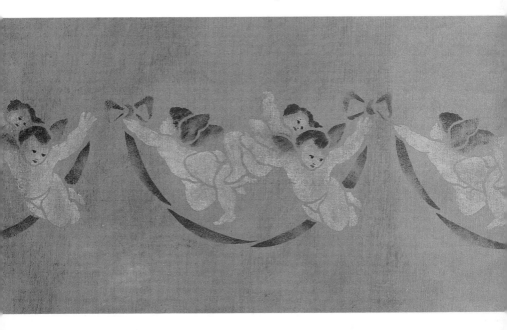

That very time I saw …
Flying between the cold moon and the earth,
Cupid all armed; a certain aim he took
At a fair vestal, throned by the west,
And loosed his love-shaft smartly from his bow,
As it should pierce a hundred thousand hearts.

William Shakespeare (1564–1616), *A Midsummer Night's Dream*, II.i.155–60

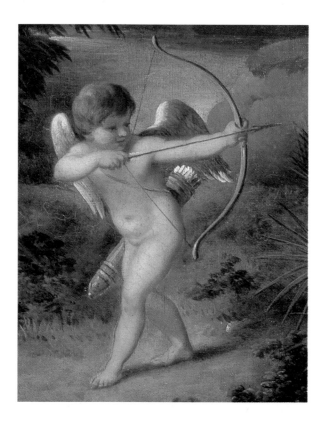

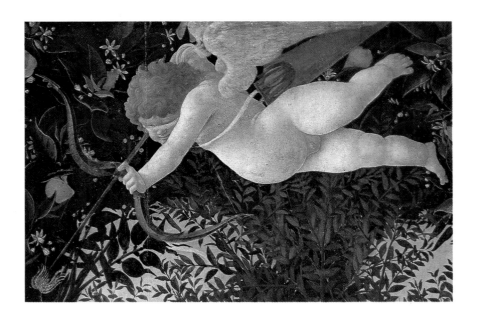

*L*ove looks not with the eyes, but with the mind,
And therefore is winged Cupid painted blind.

William Shakespeare (1564–1616), *A Midsummer Night's Dream*, I.i.234–5

THE WOUNDED CUPID

*C*upid, as he lay among
Roses, by a bee was stung:
Whereupon in anger flying
To his mother, said, thus crying,
"Help! O help! your boy's a-dying."
"And why, my pretty lad?" said she.
Then blubbering, replièd he,
"A winged snake has bitten me,
Which country people call a bee."
At which she smiled, then with her hairs
And kisses, drying up his tears,
"Alas!" said she, "my wag, if this
Such a pernicious torment is,
Come, tell me then how great's the smart
Of those thou woundest with thy dart!"

Robert Herrick, *Hesperides* (1648)

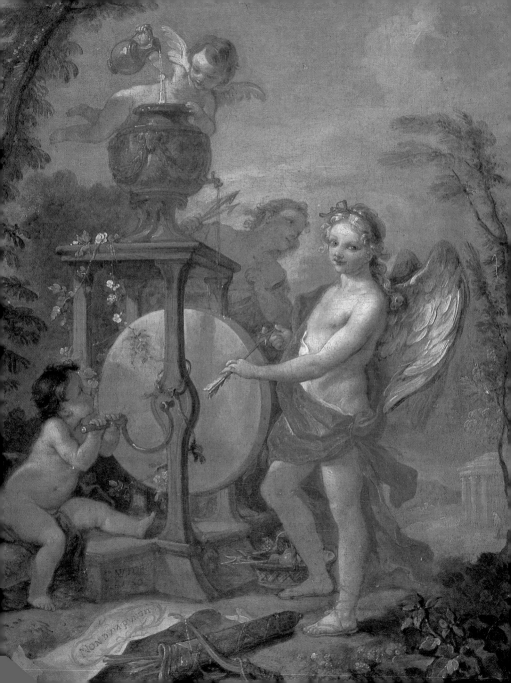

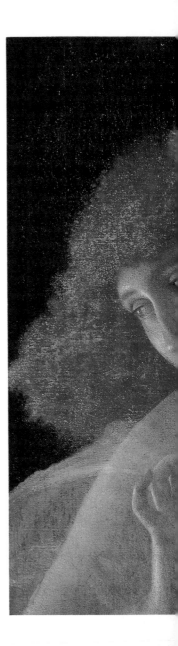

*M*y delight and thy delight
Walking, like two angels white,
In the gardens of the night.

Robert Bridges, *New Poems* (1899), No. 9

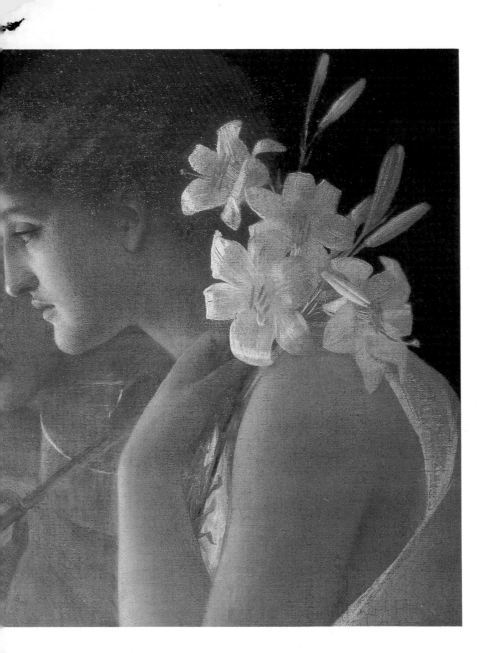

Cupid Mobile

Cupids cut from postcards or magazines, or reprinted Victorian scraps can be used for this mobile. If you have access to a colour photocopier you can enlarge or reduce the images to give a selection of different sizes, otherwise choose a number of different images. Four small ones, four medium-sized ones and one large one have been used here.

Cut a length of thin white card about 18 in (45 cm) long. Allowing for an overlap cut it into a pretty shape. Bend the card into a circle and glue the ends together. Cut out the cupids. Draw round the medium-sized and large cupids onto thin card, leaving a bit of card showing at the top to allow for a hole for the thread. Cut out the card shapes and stick on the cupids. Paint all the visible white card with gold acrylic paint. Do not forget to paint the edges.

Pierce four equally spaced holes around the coronet along the top and bottom edges. Pierce a hole at the top of each cupid. Cut four pieces of gold thread about 4 in (10 cm) long and use them to suspend the four medium cupids from the holes punched round the bottom edge of the coronet. Secure them with knots tied on the inside of the coronet and at the back of the cupids. Then cut four more pieces of thread approximately 16 in (40 cm) long and a fifth piece for suspending the centre cupid about 24 in (60 cm) long. Pass the threads through the holes along the top edge of the coronet and knot them on the inside. Add the fifth piece of thread and knot all the threads together. Attach the larger cupid to the centre thread. Stick the small cut-out cupids round the top of the coronet for the final decorative finish.

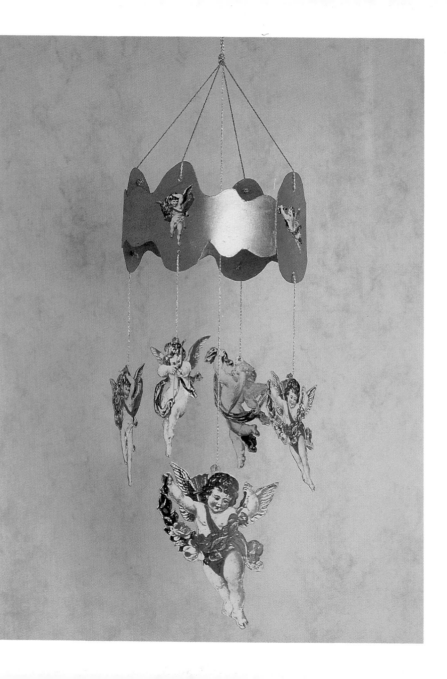

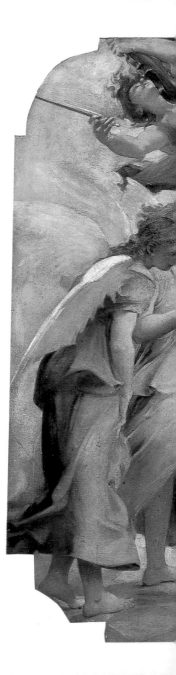

ᴀngelic
Music

*ℕow cracks a noble heart.
Good night, sweet prince,
And flights of angels sing thee
to thy rest.*

William Shakespeare (1564–1616),
Hamlet, V.ii.364–5

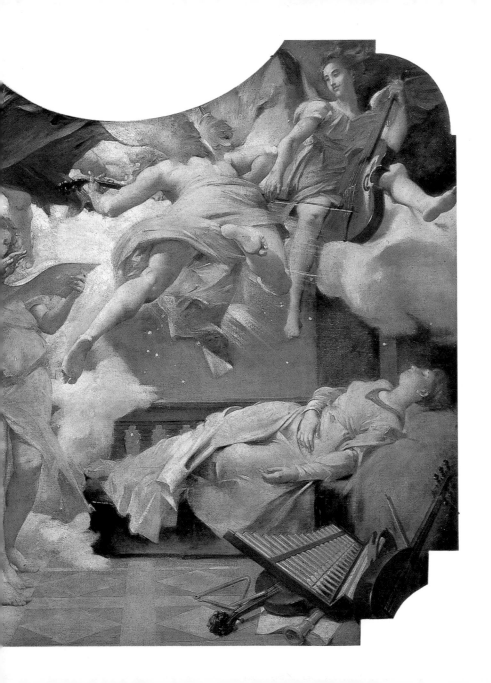

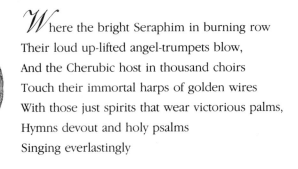

*W*here the bright Seraphim in burning row
Their loud up-lifted angel-trumpets blow,
And the Cherubic host in thousand choirs
Touch their immortal harps of golden wires
With those just spirits that wear victorious palms,
Hymns devout and holy psalms
Singing everlastingly

John Milton, *At a Solemn Music* (1633)

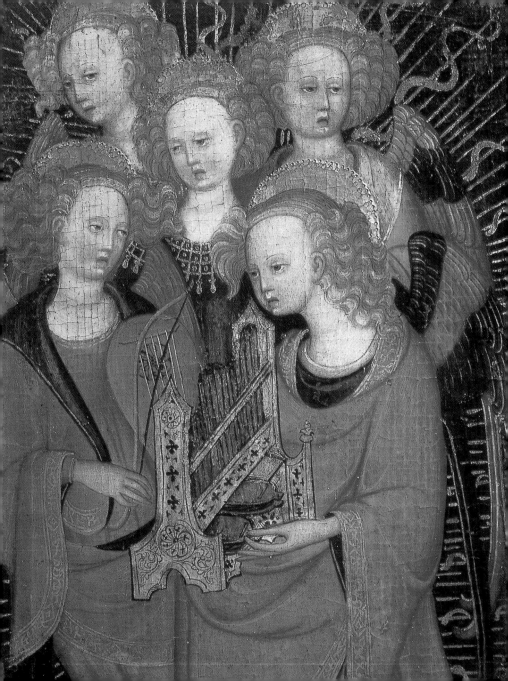

\mathcal{L}ook, how the floor of heaven
Is thick inlaid with patines of bright gold:
There's not the smallest orb which thou behold'st
But in his motion like an angel sings,
Still quiring to the young-eyed cherubins.
Such harmony is in immortal souls.

William Shakespeare (1564–1616), *The Merchant of Venice*, V.i.58–63

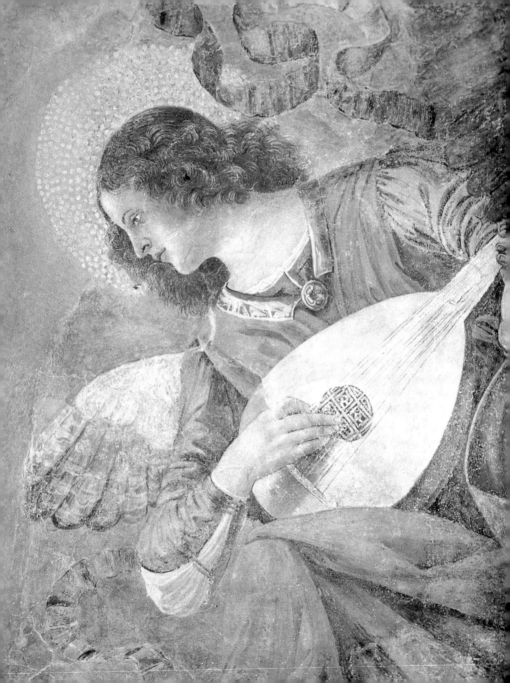

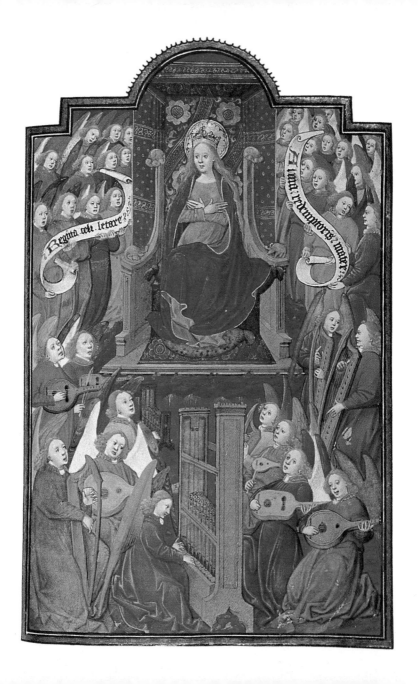

\mathscr{I}n Heaven a spirit doth dwell
"Whose heart-strings are a lute";
None sing so wildly well
As the angel Israfel,
And the giddy stars (so legends tell)
Ceasing their hymns, attend the spell
Of his voice, all mute.

Edgar Allen Poe, *Israfel* (1831)

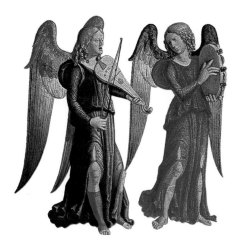

\mathscr{T}he Angels all were singing out of tune,
And hoarse with having little else to do,
Excepting to wind up the sun and moon,
Or curb a runaway young star or two.

Lord Byron, *The Vision of Judgement* (1822)

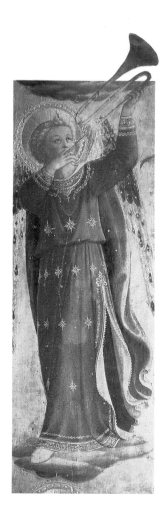

\mathcal{A}t the round earths imagin'd corners, blow
Your trumpets, Angells, and arise, arise
From death, you numberlesse infinities
Of soules

John Donne,

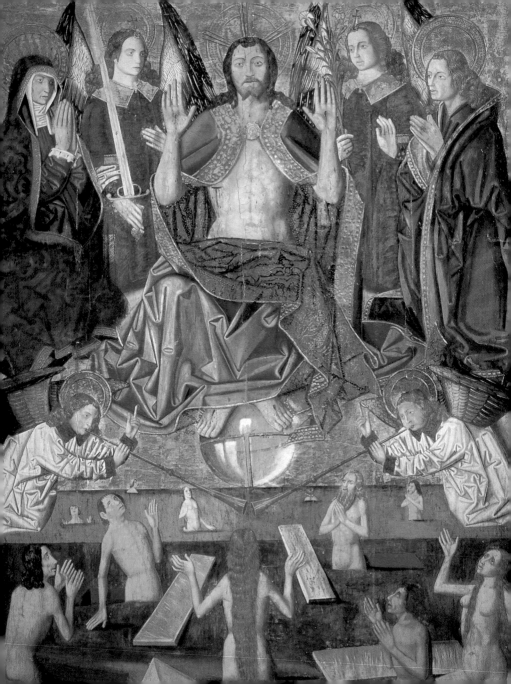

\mathcal{T}in Angel Decoration

\mathcal{S}hiny, punched tin makes charming folk-style decorations. You can recycle old tin cans or use metal foil bought in strips from sculpture suppliers. If the tin has a design on it remove it with paint stripper before you begin.

\mathcal{C}ut a piece of tin measuring about 7 × 11 in (18 × 28 cm) with tin snips or strong scissors. Wear protective gloves. Wash it in hot water and detergent to remove any grease. Draw the outline of your angel with a soft pencil and cut it out. Gently smooth the edges of the shape with a small metal file. Draw the angel's features on the wrong side of the shape. With the tin right side down on a work surface, position the point of a flat-headed nail at the beginning of one pencil line. Gently tap the nail with a small hammer to produce a small indentation and then move along the line repeating the process. This will produce lines of raised dots on the right side of the angel. To suspend the angel, punch a hole right through the top and tie on a loop of silver thread.

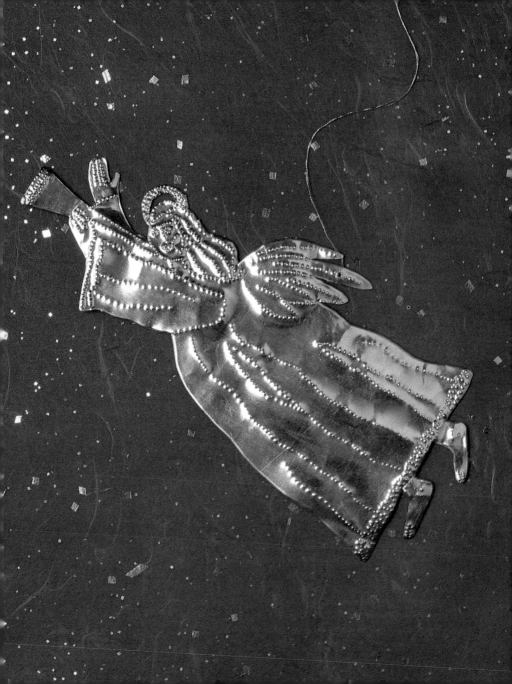

Acknowledgements

The Publishers would like to thank the Bridgeman Art Library (BAL), the E.T. Archive (ETA) and the Visual Arts Library (VAL) for the loan of the pictures included in this book.

Front cover, Fiorentino, *Angel playing the Lute* (BAL); back cover, Correa, detail from *The Nativity* (BAL); end papers, Murillo, *Cherubs Scattering Flowers* (VAL); page 2, Fra Angelico, detail from *The Annunciation* (BAL); 6, Meister des Hausbusches, *Three Angels* (VAL); 7, Master of the St Lucy Legend, *Mary Queen of Heaven* (BAL); 8, Fra Angelico, detail from the *Last Judgment* (BAL); 9, Altdorfer, *Birth of Mary* (ETA); 12, Sir John Soane Museum Book of Hours, *Assumption* (ETA); 11, Ghirlandaio, panel from the Figline Altarpiece (BAL); 12, Romano, detail from the *Mythological Banquet* (VAL); 15, Turner, *Angel Standing in the Sun*, (VAL); 18, Velasquez, detail from *The Annunciation* (BAL); 19, Mann, *The Guardian Angels* (BAL); 20, 13th-century German Romanesque relief (ETA); 21, Book of Hours, *Angel of the Nativity appearing to the Shepherds* (VAL); 23, Blake, *Christ in the Sepulchre, Guarded by Angels*, by courtesy of the Board of Trustees of the V&A (BAL); 24, French Christmas card 1905 (ETA); 25, Christmas card (ETA); 26, detail from an English sampler 1727, Fitzwilliam Museum, University of Cambridge (BAL); Jacob's Ladder silk embroidery c.1660, Holburne Museum, Bath (BAL); 30, Correa, detail from *The Nativity* (BAL); 30–31, Botticini, *The Three Archangels and Tobias* (BAL); 32, Lippi, detail from *Annunciation* (BAL); 33 top, Master from Cologne, *The Annunciation* (VAL); 33 below, Book of Hours of Alfonso of Aragon, *Annunciation* (ETA); 35, Rembrandt, *The Archangel Raphael leaving Tobias's family* (VAL); 36, Memling, *The Archangel Michael* (BAL); 37, Ricci, *The Fall of the Rebel Angels* (VAL); 38,

Swanenburgh, *Fall of Satan and the Rebel Angels from Heaven* (BAL); 39, Lochner, detail from *The Last Judgment* (BAL); 42–43, van den Hoecke, detail from *The Choice of Hercules between Vice and Virtue* (ETA); 43, Podesti, detail from *The Triumph of Venus* (BAL); 44, Huet, detail from *Cupid Commemorating a Marriage* (BAL); 45, David, *Portrait of Madama Guimard* (BAL); 46, Matteis, detail from *Cupid and Psyche* (BAL); 48, Cipriani, *Three Cupids*, by courtesy of the Board of Trustees of the V&A (BAL); 49, Wedding card c.1890 (VAL); 52, Reinagle, detail from *Cupid Inspiring the Plants with Love*, Fitzwilliam Museum, University of Cambridge (BAL); 53, Botticelli, detail from *Primavera* (BAL); 55, Natoire, *Cupid Sharpening his Arrow* (BAL); 56–57, Sellier, *Two Angels* (BAL); 60, detail from Victorian postcard (BAL); 60–61, Baudry, *The Dream of St Cecilia* (BAL); 62, Serra, *Angel playing a Harp* (BAL); 63, Verona, *Angels playing Music* (ETA); 65, Melozzo da Forli, fresco fragment *Angel with a Lute* (VAL); 66, 16th-Century illuminated manuscript, *Virgin and Angels* (VAL); 67, Martini, *Musical Angels* (ETA); 68, Fra Angelico, *Angel playing a Trumpet* (BAL); 69, retable of Church of Blesa, *The Last Judgment* (ETA).

Page 20, extract from *A Handbook of Angels* included by kind permission of The C.W. Daniel Co. Ltd.
Page 47, extract from *Cupid & Psyche* included by kind permission of Cambridge University Press.

The Publishers have made every effort to identify copyright holders of material included in this book and apologise for any inadvertent omissions which will be rectified in the event of a reprint.

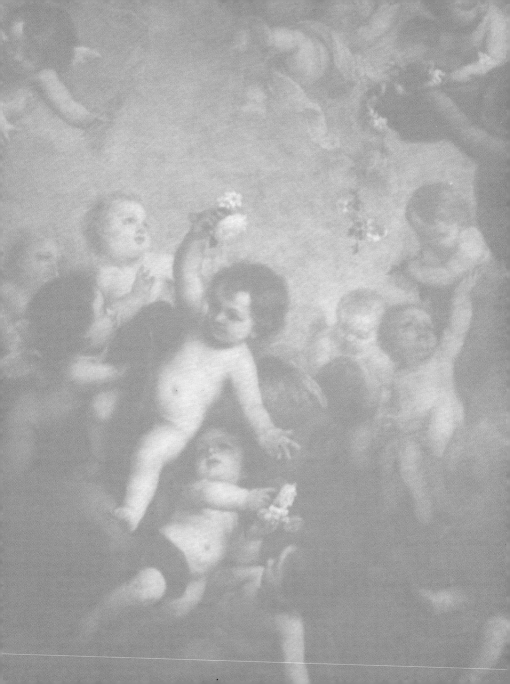